THE MAD MONK

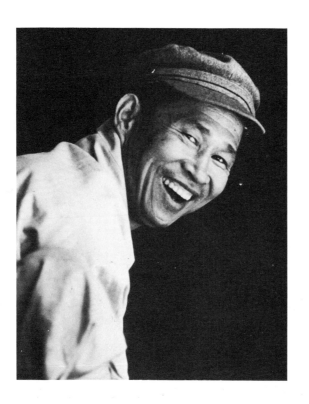
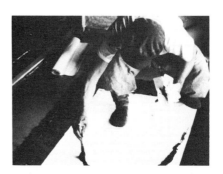
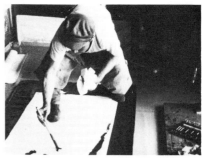
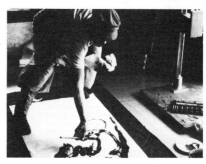
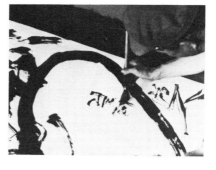

THE MAD MONK:

PAINTINGS OF UNLIMITED ACTION

by

Jung-kwang

With an Introduction

by

Lewis R. Lancaster

LANCASTER—MILLER PUBLISHERS
BERKELEY, CALIFORNIA 1979

Other titles in the Lancaster - Miller Art Series:

California Murals
text by Yoko Clark and Chizu Hama
Photographs by Marshall Gordon
ISBN 0-89581-106-0

Colored Reading
The Graphic Art of
Frances Butler
ISBN 0-89581-011-5

Dragons and Other Creatures
Chinese Embroidery
by Katherine Westphal
ISBN 0-89581-012-3

Mel Ramos: Watercolors
ISBN 0-89581-009-3

Buttons: Art in Miniature
by Stefan O. Schiff
ISBN 0-89581-013-1

Copyright © 1979 Lancaster-Miller Inc.
3165 Adeline St.,
Berkeley, California 94703

ISBN 0-89581-017-4

Library of Congress Catalog No. 79-92349

Photography of original art work by Hyun-kuk Chon.

Portrait of Jung-kwang facing title page by William Hocker.

Action sequence by Lois Lancaster.

Acknowledgement is made to Mr. and Mrs. Clyde L. Juchau for assistance in the production of this book.

INTRODUCTION

Jung-kwang is a celebrated artist in his country, the Republic of South Korea. This Buddhist monk is a controversial figure, engaged in unorthodox activities of concern to the more restrained members of the Buddhist community. As an artist, he has received attention from both strong supporters and equally strong critics. Yet regardless of their views of his paintings, his ability as an appraiser of Buddhist art is unquestioned. He sits on the boards and committees of national museums, and has served as art adviser to the National Council of the Chogye Order, the main governing body of the monasteries of Korea. Copies of his paintings appear in newspapers and on covers of magazines, often alongside articles containing his candid responses to reporters' questions. These articles have kept his name before the public.

On a personal level, he is difficult to judge, because though he behaves as a wild man, he is a respected member of the organized art world of Korea. He refers to himself as a "mad monk," and while walking about the streets he is alternately greeted with enthusiasm and assailed with hostile glances. My own conclusions about him arose from our meeting in 1977 and subsequent travels about Korea under his guidance. I experienced Jung-kwang as both a difficult and delightful man, and in sharing my contact with this unusual individual, I ask the reader to judge him by his paintings and philosophy, as well as by his actions.

Jung-kwang was first known to me as "the man with the key," in his capacity as director of the Tong-do Monastery Museum. In 1976 I had come to Tong-do, situated in the river valley just to the north of Pusan, to photograph and observe life in the Korean Buddhist monasteries. Surrounded by sharply rising mountains, cradled by the late-summer green of ripening rice fields and a forest of native pines, the monastery indeed appears as one of "the three jewels" of Korean Buddhism.

Though few Korean monasteries pay attention to art, Tong-do has established a small but increasingly important museum housing a collection of paintings and artifacts that are not represented in the national museums. I was drawn immediately to this museum. Impressed by the displays, I decided to make photographs for the archival collections at the University of California.

To my consternation, the objects were locked in glass cases. Not even the best photographic equipment is adequate to solve the problems presented by glare and dust. When I asked the monks to open the cases, they shook their heads in sympathy and said that the director, Jung-kwang was the only one to have control of the keys. He, being a great traveler, was away for an unknown length of time; and so my wish could not be granted.

Though disappointed, I was not surprised by this occurrence. Asia is filled with interesting

rooms and buildings that are locked, and the key is inevitably in the possession of somebody who is absent. In Nepal, a few years ago, I trekked for two weeks to reach a remote monastery in the Rowaling Valley, an isolated settlement of Sherpas near the Tibetan border. Arriving at the village following an arduous hike, I was greeted with the news that I could not see the manuscripts and xylograph copies of the Buddhist texts I had journeyed to see, because the "man with the key" was gone on a trip of unknown duration. On that occasion, I gambled: I pitched my tent and waited. After nine days the wandering monk returned.

Unfortunately, on this occasion in Korea my time was limited and it was not possible to wait. We photographed a few items not behind glass, and left with plans to return the following year and complete the project, even if we had to pitch a tent.

These Korean visits were the result of my desire to see some of the surviving monasteries of the Buddhist tradition, a tradition which I then believed to be fading fast. My survey of the library's available materials seemed to indicate that a visit to Korea would reveal only remnants of the past. But my travels dismissed these previous conclusions about Korean Buddhism. I saw a lively and growing movement, embodying the ancient glory of East Asian Buddhism. Thousands of monks and nuns still lived according to the ancient rites, practicing long periods of meditation, adhering to the vows of celibacy, poverty, and abstinence from stimulants. I was impressed by the calm of these monastic dwellers, who seemed to be withdrawn into their own inner worlds. My interest and respect grew with continued contact, and I left Korea after that first visit, determined to dedicate a part of my scholarly efforts toward making better

known Buddhist history and literature of this much-maligned and troubled nation.

Through the years, I continued to visit Korea, and I adhered to my goal by publishing a catalog of the Buddhist canon preserved on more than 81,000 printing blocks. After my 1976 trip, I secured financial assistance from the University of California Expeditions Program which allowed me to return to photograph and study the monastic sites. Among my plans was to find the "man with the key" at the Tong-do Museum.

Thus in the fall of 1977, I was stationed in a tiny inn near the gate of the monastery, awaiting the monk's return. After what now appears to be the prescribed length of time for a monk's absence, nine days, had passed, he returned and a message was sent to me at the inn. I hastened up the road to the monastery, and as I drew closer I noticed a stir of activity as monks of all ranks gathered about.

They parted at my arrival, and I looked into Jung-kwang's room for the first time. Seen through the doorway was a framed vision of chaos: old books and manuscripts were stacked against one wall, some collapsed under the weight of the unwieldy items placed on top. The clutter of paintings, rolled canvas, heaps of rice paper, framed pictures, and artistic debris of every imaginable kind, made the room appear as if a sealed chamber of treasure had been pillaged. In the gloom of the large chamber a low table of sizable proportions stood, stacked with mounds of paper that threatened to engulf it. In the one small area preserved from this chaotic disarray, sitting on a cushion, was the long-sought Jung-kwang, my "man with the key."

As his quarters shocked me because they differed so radically from the usually neat, sparse arrangements of a monk's quarters, so Jung-kwang's dress presented a surprise: his wrinkled

robe had spots of paint. He smiled, invited me to sit, and ordered tea.

It comes as a surprise in Korea to find that most people do not drink tea regularly. Instead, they drink the warm water left over from cooking rice, or a drink made from toasted barley. Tea-making is an art, a practice most often reserved for the Buddhist monks.

My host brought out cups and the ubiquitous electric coffee pot to heat the water. He started to show me the various items that were stacked, rolled, or dumped about the room, and my excitement grew as each new item was revealed. My mind reeled at the treasures which lay buried in this room — old folk paintings, drawings of the zodiac animals, rubbings of printing blocks, books, and manuscripts.

In my excited state, I stumbled and knocked against the electric coffee pot, an anomaly in this room of old and beautiful art works. The pot turned over, pouring boiling water over my foot, and threatening to spread to the surrounding mounds of stored paper. Cloths were thrown down to absorb the water while I, attempting with little success to preserve my dignity, hopped about the room in pain. Thus began our friendship.

Among the paintings, I spotted one striking ink sketch, primitive in execution but bold and powerful. I exclaimed over it to my host, applauding the effectiveness of its brush strokes. He looked at me with a speculative glance and asked, "Why do you like this?"

"It's like a Zen painting should be and so seldom is," I replied. I had seen a good deal of Zen painting and discovered all too often that the quick sketches of the brush-and-ink artists are precious, self-conscious expressions of immediacy. This brush work, however, was so forthright and lacking in self-consciousness that I responded to it instantly. After a pause, he said with a laugh, "This is my very own painting."

From that moment our relationship changed. I had passed a test, and the barriers between us began to fall as he shared with me his work and his problems. He told me of his discouragement at having monks reject his work because of its nonconformity with the hallowed canons of painting. A few of his fellow monks as well as a number of museum people and collectors had given support to his work, but Jung-kwang had pursued his art without thought of selling it. He had given an occasional painting to a few of his friends, but most of his collection was stuffed into closets and drawers in monasteries and Buddhist hermitages across Korea.

Looking at one of his animal paintings, so humorous and yet removed from the attempt to be humorous, I remarked, "You are the Picasso of Korea."

Jung-kwang snapped back, "I'm better. His paintings are filled with thought, mine are not."

We sat for hours looking at the work scattered about his room at Tong-do. There we formed a plan to publish a volume containing a collection of his paintings. It would be necessary to gather his best work from a dozen spots scattered about the country, and then get these works to a photographer in Seoul. We made arrangements to meet in my hotel lobby one week from that day to begin our journey.

What a journey it was to be! Buses, trains, planes, taxis, and long hikes took us to our various destinations. For more than two weeks we criss-crossed the country. During that time we came to know each other as only fellow voyagers can.

When I first saw Jung-kwang, I had sensed in him a different kind of monk, an artist to be sure, but also an individual who behaved in an

unorthodox style. I joked with him about his manner one day when he was happily drinking from a bottle of whiskey. He responded that he practiced "unlimited action," and was no longer bound to the strict rules that govern monastic life.

Korean Buddhist history is filled with the stories of such monks and nuns, who, having achieved a high state of insight, turn away from the limiting social rules to live according to an internalized order. These individuals often exhibit extraordinary behavior, including uninhibited actions, often labeled "immoral." While I had read of such people (one of the great founders of the Buddhist monastic tradition, Won-hyo, belonged to this group), this was my first exposure to someone who professed to practice such a lifestyle in the present day.

Eagerly, I began to question him and challenge his behavior, which struck me as undisciplined and self-indulgent. As he told his story, I recorded in my notebook what he said:

"When I was first in the monastery, I was known as one of the best meditators. I meditated so much that I developed calluses from having my feet in lotus posture so long. Once I went for two years without changing my clothes. I walked outside in the same way, whether it was raining or snowing or a clear sunny day. During those years, the rain washed me. Finally came the day when the difference between meditating and not meditating disappeared. Every act, every word was meditation. From that time on, I have practiced 'unlimited action.' Sometimes I sleep—sometimes not. When I am hungry I eat, and sometimes for days I eat nothing. I sometimes drink only water, and other times bottles of wine or whiskey. I have slept with a thousand women; one was hunchback and no one wanted her, but to me she was

the same as the most beautiful women, and I gave her love and she became a happier person. I never hurt anyone by my actions. I am a 'Buddhist mop.' A mop is something that gets dirty itself but makes everything it touches clean. I *have* to act in this way, I have to live the Buddhist doctrine that there are no distinctions, that right and wrong are projections of our mind. By living 'unlimited action' I daily teach the message of Buddhism. There should always be a few like me to remind people of their habits and patterns."

A young monk listening intently asked, "Should I act like you?"

"No, no, no! If you need to ask, then you must meditate and follow every rule without exception. Only when the winter snow is the same to you as the warm summer evening and the rain is like sunshine can you consider such activity. If a person who is not ready practices this way, it is draining; he will fade and grow ill within a few weeks. I have practiced 'unlimited action' for years and I am always rested. Had I pretended, I would have died long ago."

While Jung-kwang's statements echo the texts of Buddhism and the remarks of many of his countrymen who had practiced "unlimited action," I found it nonetheless difficult to accept his comments. My intellectual observations left me ill-prepared to travel with a monk who practiced such an unorthodox lifestyle. I was yet to discover just how overwhelming such an experience could be.

One of our first stops was at the famous Hae-in Monastery on Mt. Kaya in the interior of Korea. Here we planned to spend a few days talking with the monks and examining the art contained in the monastic buildings. That night was one of those eerie East Asian fall evenings when the sky is clear and the moon seems too

bright to look at. At 9 p.m., when the monks retire to their rooms, I also sought my bed. Jung-kwang remained on the veranda, and later, as I began to doze, I heard him singing. Climbing out of bed, I opened the window. There in the moonlight he was slowly dancing, alone and in harmony with the night and the sky.

In the predawn darkness, Jung-kwang shook me awake. "Let's go visit the nuns," he said. Pulling myself to consciousness, I looked at my watch and saw that it was just past 3 a.m. "But Jung-kwang," I pleaded, "it's too early — they won't be up yet."

"Well, they should be up early, and we will need breakfast," he replied.

I pulled on my rumpled clothes and set off through the darkness. The path was narrow and wound up and around the side of a mountain. Our dim flashlight gave only a hint of the path, revealing none of the small streams, through which Jung-kwang marched without a pause, and I sought to avoid with little success. We approached the nun's quarters to find the total stillness indicative that all within were asleep. Jung-kwang, undaunted by the signs of repose, banged on the gate and shouted, "Hey, where are you? Visitors here. Are you meditating?"

The silence dispelled by his voice was replaced by the faint rustle of robes and the scrape of doors opening as finally a point of light approached the gate. A nun calmly opened the gate and invited us to enter. Jung-kwang announced his hunger, and we were ushered into a small room. My earlier embarrassment at arriving in such a fashion faded as the nuns greeted us with pleasure. Food began to arrive: fruit, a hot milk drink, and finally a full meal of rice, seaweed soup, pickled fern fronds, aspic made from acorns, cooked green herbs, and of course kim chee. As the sun rose, we sat with the door of our room open looking out across the distant valleys and mountains, sipping the warm water left from cooking the rice. The welcome we received from those nuns in that lonely spot, I'll never forget.

Later that day, still sleepy from the early morning visit, I sat quietly on the steps of the guest house. Jung-kwang, hurrying across the compound announced, "I'm tired of this place, let's go to Pusan."

"But Jung-kwang, it's already nearly 5 p.m. and it takes four or five hours to get there by bus; let's go tomorrow."

"Are you coming?" he asked as he gathered up his small gray cloth bag, the extent of his luggage, and started at a brisk pace down the trail toward the bus stop. I frantically tore about the room collecting my clothes, camera, books, film, and suitcases, then rushed down the path after him. All my gear was tied to a small wheeled luggage cart and kept falling off as I tried to keep up with Jung-kwang on the rough dirt path.

Our group, comprised of Jung-kwang; Mr. Woo, my assistant; a young American monk, Hei-myong; photographer Bill Hocker; and myself, headed for Pusan. We arrived late that night at the house of a publisher friend of Jung-kwang's. The household had already prepared for bed, and our arrival caused some confusion that echoed throughout the building, which housed both business and home. The host, accustomed to the comings and goings of Jung-kwang, arranged for our food, beds, and refreshments.

The host said to Jung-kwang, "I'm doing all of this for you, and you have never painted a picture for me. You should do one tonight."

"Fine," said Jung-kwang, "you must get together all the materials: new brushes, paper,

wine, cigarettes, dried squid, a radio, and someone to grind up the ink stick."

The boys of the family were sent flying about the shops to gather these supplies. As soon as dinner was cleared, the stage was set for Jung-kwang. We sat facing him in a half circle while he fussed about with the paper, tested the ink, then tasting it and pronouncing that all was ready. He then opened up the wine and started to dance to the music on the radio, an ersatz Korean version of American rock and roll. He twirled about the room, copying the traditional shamanistic dances, alternating sips of wine and bites of squid. As the tempo increased, he kicked articles out of his way and danced with increased energy. Then suddenly he tore off his clothes and turned toward us with the brush poised in his hand. With agility he bent over a sheet of paper and in a few seconds made a painting of Bodhidharma, the great saint of the Zen tradition. His movements were absolutely controlled, in sharp contrast to his drunken swagger while he was dancing.

During the next minutes, he made six paintings, punctuating the process with more wine-drinking, smoking, dancing, eating, and laughing. He donned the discarded clothing and sat quiet and calm. "Show me what I did," he said with a voice that seemed suddenly dim and near weariness. He looked at each of his paintings, sometimes exclaiming in joy over a brush stroke. He picked up the last painting and crumpled it in his hand, saying (in English), "No good."

Exhausted by the day's activities and by the recent spectacle, we all went to our beds, but Jung-kwang left the house to wander through the city streets, unable or not needing to sleep.

As my travels with Jung-kwang continued, I slowly learned to follow the rhythm which never followed a predetermined pattern. No more schedules were made; and my notebook filled with dates and lists of things to be accomplished was packed away. I began to enjoy events as adventure. One day we entered a bus station bound for one of the monasteries that held some of his art work. Jung-kwang stood for a moment looking at the schedule of buses, shrugged his shoulders as he noted that our bus was due in a half-hour, and without a word climbed on a bus going in the opposite direction. I took my seat beside him without a protest. After we had passed several towns, Jung-kwang announced, "We have come to a good place. There is a good restaurant here. Let's have a meal." And so we sat in the autumn evening and ate, while Jung-kwang flirted with the waitress who knew him well.

This is not to say that I had become completely successful in throwing off the layers of conditioning that had dictated my actions and thoughts. Each day of our trip, I was given a demonstration in just how short of enlightened action my state of mind was. Jung-kwang seldom allowed a conversation to follow the lines of conventional dialogue. He used "Dharma talk," infusing our interactions with Zen "koans," interchanges with which the teacher attempts to throw off the mechanisms of reason that limit his pupil. As Jung-kwang sensed that I was beginning to parade information from the world of the senses, he would begin to question and probe as in the following dialogue:

"The weather is very warm today," I casually remarked.

"What is warm and what is not-warm, please show me," he replied.

Me, puzzled, "The weather."

"Where?"

"Everywhere!"

"Is there something which is not-weather?"

"Well, yes," I retorted, "this tea pot is not."

"Ha, so weather is not everywhere," he laughed.

My wife fared better than I in these exchanges. One night toward the end of our trip, as we sat laughing and talking at a party, Jung-kwang handed her a newly lit cigarette. She was already in the process of smoking a cigarette, so he watched with interest as he handed her this second one. Without hesitation, she inserted it between two other fingers and proceeded to smoke the two at the same time. He was delighted and pronounced, "That is the way, no second thoughts, no following the usual patterns." For the rest of the evening, he beamed at her, and that night he painted a figure of Bodhidharma as a female smoking two cigarettes.

These exchanges were not exclusively reserved for teacher-pupil exchanges. I observed Jung-kwang resort to "Dharma talk" on several occasions when in the midst of an angry argument. Because Jung-kwang would not stick to schedules, we often arrived at a monastery long after the monks had retired for the night. To the annoyance of the monks or nuns, and their terror of robbers, my companion reacted with amusement. One night we arrived at a remote monastery high in the mountains. Jung-kwang walked around the deserted courtyard, yelling, "Hey!" After no response, he yelled louder, "I said, hey!"

A voice muttered, "Who are you?" as the door opened a crack.

"I'm Jung-kwang. We need a bed. Hurry up sluggard."

"I don't care who you are—don't call me a sluggard, coming here in the middle of the night; go away." And with that he slammed his door.

"You think you can turn me away? Hey! Hey!"

"You insulted me," the monk said as he again stuck his head out of his door.

"We need a bed. Hurry up, sluggard." And then, with a sudden smile, "Don't be so limited—getting up, lying down, it's all the same."

The monk, now reluctantly smiling, "Then I'll just be lying down again."

Jung-kwang, frowning: "Then I'll just be yelling again. Hey!" No response.

"I said Hey, hey, hey!"

I waited with some apprehension for the answer.

"I heard you."

"At last you're enlightened."

The monk yielded to the force of Jung-kwang's presence. He emerged from his room and entertained us with great care.

As the days progressed, I lived with a strange sense of well-being. The memories blend together, and much of what transpired seems to have all taken place in one day—breakfast of hot milk and cake in a tiny grocery store; being pulled into a doorway, and there finding a room filled with pools of mineral water in which to soak away the pain of nights spent on hard floors; luxuriating in a barber shop for hours while being shaved, trimmed, and massaged; and laughing as Jung-kwang greeted an endless line of friends.

One day toward the end of the trip, Jung-kwang spotted a new issue of one of Korea's most popular magazines, which announced in its headline, "Strange Monk Eats Meat and Has Sex." On the cover appeared a picture of Jung-kwang, and the article inside gave the more lurid facts of Jung-kwang's lifestyle: sleeping with numerous women, engaging in sex with animals, drinking, and smoking. I was dismayed to see his life of "unlimited action" subject to such degradation.

"Jung-kwang, why did you tell them all that?" I asked. He looked at me with surprise and also a bit of disappointment, and replied, "A man of unlimited action tells no lies, does not cover up. I am pleased with the article. He tells the things I told him."

The magazine's popularity was soon apparent. We met a monk on the street, who, catching sight of Jung-kwang, came over waving the magazine and shouting at him, "You're not a monk. Why do you wear the robe?" Saying this, he made as if to tear it off. "I am a monk, and you will never take my robe off," declared an unperturbed Jung-kwang.

Wherever we went, people pointed and either accosted Jung-kwang, or stood in laughing groups. I finally asked him, "Did you do all those things mentioned? Did you have sex with animals?" "Yes," he answered, "all sentient beings have the Buddha nature. Why make distinctions?"

I remained troubled by this publicity while Jung-kwang seemed undisturbed, even as the furor reached to the highest circles of government and within the Buddhist order. Jung-kwang was not subject to shame, and his unconcerned manner of handling the problem was one of the most impressive aspects of my travel with him.

Sensing my concern, he told me one day, "When I paint a picture, my brush must move without hesitation. There can be no mistakes to be corrected. Only when there is unlimited action can the brush move with force and power." He took out one of his paintings and pointed to a bold line running from top to bottom. "Look at that line. It is the line of enlightenment. There is only one line like that in the universe, and it will never be made again. You cannot think to make such a line and suc-

ceed; it must come from having no limits to your action of painting the line."

Through these incidents, my mild-mannered professorial approach to life was continuously tested. Jung-kwang was a man who spoke with deep understanding of the highest teaching of the Buddhist tradition. He was no renegade monk, but rather a trained meditator who had achieved a state of enlightenment granting him a freedom in direct opposition to my own carefully controlled approach to life. I sensed that I was undergoing profound changes as a result of the contact with Jung-kwang, and I became less sure of my own "rational" processes.

Once we arrived late at night, our usual procedure, in a small town that is still nameless in my memory. The streets were dark except for a shaft of light emanating from a single sign hanging from a small hotel.

"You'll like this place—one of my disciples owns it," he said. The small lobby looked unused, but laughter and music could be heard from a room further back. Jung-kwang knew the way, and led me to a large lounge where a dozen or so women, carefully dressed in Korean costumes, gave their attention to the customers —all men, drinking and talking.

"Which one is your disciple?" I asked with some puzzlement. I followed him down more corridors until he threw open a door and boomed out his greeting. A handsome older woman, still showing the beauty of her younger years, jumped with surprise. Like so many others, she seemed glad to see him and we were soon settled in a room which was filled with expensive Western-style furniture. After a time she began to talk of her conversion under the aegis of Jung-kwang, all the while fingering her prayer beads. She was full of questions about Buddhist doctrine and took advantage of my

professorial presence, asking some intelligent and penetrating questions. Before long the two of us were left to our intellectual profundity while Jung-kwang roamed the hotel enjoying the company and periodically raised a howl of laughter as he sparred with the hostesses. Near dawn, we ate a meal and Jung-kwang led me back to the bus station.

A day late, we took our final train ride into Seoul. The car was crowded with late afternoon commuters, and the air inside was hot and stuffy. The passengers were quiet and aloof, tired from a day at work. Jung-kwang strolled up and down the aisle, stirring up talk and laughter among the people, teasing the young girls who hid their faces in giggles at his outrageous remarks about their beauty. When he returned to me, I offered him my seat, but he pushed me back into it and sat down on the floor. Assuming a meditation posture, he went to sleep, surrounded by a crowd of commuters. He appeared fragile, alone on the floor. We looked at each other and at him, and waited quietly as he slept, as if standing guard.

After two weeks of intensive travel, I had to announce to Jung-kwang that my time of departure had arrived, as my airline ticket required that I leave on a set date. I waved my sheaf of tickets as if to testify to the importance of my schedule. My old patterns began to reassert themselves. He reminded me that there was a collection of paintings in a small monastery in the mountains in the central portion of the country, a collection that should certainly be seen. I replied that I could not see them this time, again waving my tickets. Jung-kwang shook his head with wonder as I looked at the offending tickets, which now lay sagging in my hand. What a flimsy barrier sets our paths on their given courses.

Though I left Korea as scheduled, Jung-kwang's influence over me has lingered. Even now, as I write this introduction to his paintings, selected with his assistance, his spirit seems to hover about me, and I remember with fondness our travels together.

Jung-kwang's path is one which most of us could not follow. His lifestyle demands long nights without sleep, periods with inadequate food, extended travel, arduous hikes, and endless wandering along the pavement of Korea's cities. Accompanied by small shopkeepers, prostitutes, rich executives, monks, nuns, professors, children, and newspaper reporters, he makes no distinction amongst them. My influence over him as a foreign scholar was no more profound than the man at the fruit shop.

Despite my onslaught of questions about his actions, not once in our travels did Jung-kwang retreat from his doctrine of unlimited action. Each moment was a surprise to me, and in this unaccustomed lifestyle, a new awareness engulfed me. For a limited period, I dropped my professorial facade and allowed this "mad monk" to carry me along on a new path.

Jung-kwang said of the path of unlimited action: "If the one who practices it is dead, there is reverence; if he is alive, there is bound to be trouble." His compatriots are found among the ancient Taoist sages and monks, among the eccentric and often despised shamans of every culture. Still, few other societies or religious traditions could have absorbed a person of such eccentricity as easily as the Korean Buddhist.

In these anecdotes, I have attempted to share the experience of living in the presence of this unusual person. His paintings, too, are an expression of his lifestyle, and they are filled with the same vigor he displays in life. They are iconoclastic, poking fun at individuals or sacred objects. And they always challenge the viewer.

The art, all of it completed in a few seconds, exemplifies "unlimited action" with the brush. These paintings are executed without hesitation, without thought.

I believe that Jung-kwang's painting deserves the attention of Westerners, as well as of his fellow countrymen, for it shows us the outer limit of painting, a point where each brush stroke is the whole of the experience and contains the spirit of the artist.

Whenever I look at these paintings, I see Jung-kwang's face beaming as he admires his work, holding up a closed fist, the thumb pointing up, and pronouncing, in English, "very good."

— Lewis R. Lancaster
Berkeley 1979

THE PLATES

An angry monk argues with Jung-kwang,
finally tearing his robe. "You are a
disgrace. Take off that robe. You are no
monk!" Jung-kwang brushes his hand
away. "Robe or no robe. Monk or no
monk. I live the Dharma. You talk it."

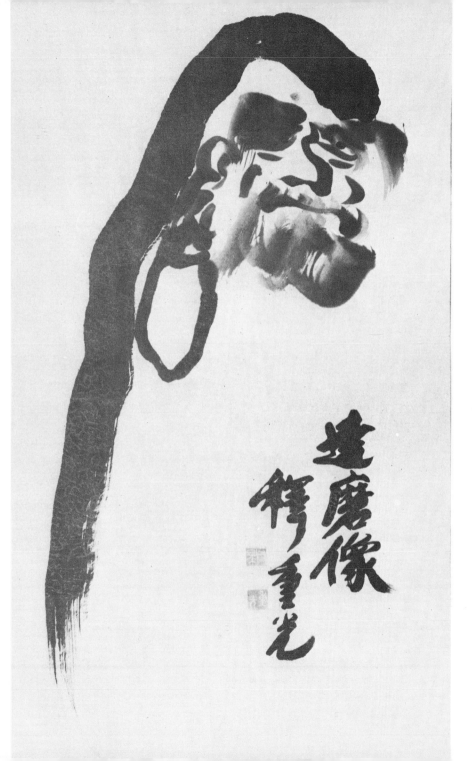

達磨像 釋重光

Jung-kwang asks, "How much does this
glass of water weigh?"
Puzzled, I reply. "I don't know.
Half a pound or so..."
He slaps his hand on the table and laughs.
"Are you still measuring?"

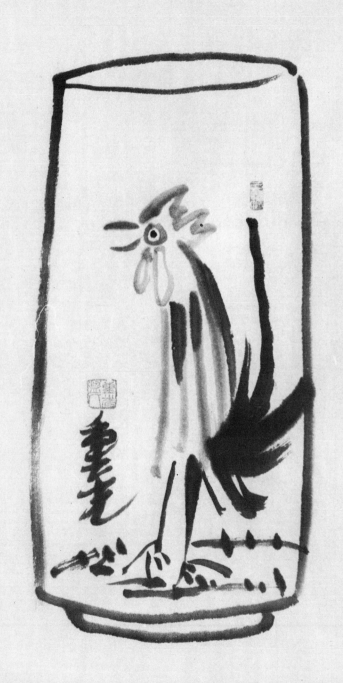

I'm a Mop
Living
As if half-sane and half-insane.
The whole universe is being shattered into pieces.
I feel so lonely
That I dance gently up and down.

I'm a Mop
The carp in the Namhan'gang River
Is fresh.
Load a barrel of rice wine and
Set a boat afloat.
Stars, moon and fish
Gather together:
Stars sing songs
The moon plays an hour-glass drum,
The fish with knives
Carve out a slice of raw meat.

I,
Downing a cup of rice wine,
Dance lively and joyful
Dance in high spirits.

I'm a Mop.

Bodhidharma walking on his jaws.

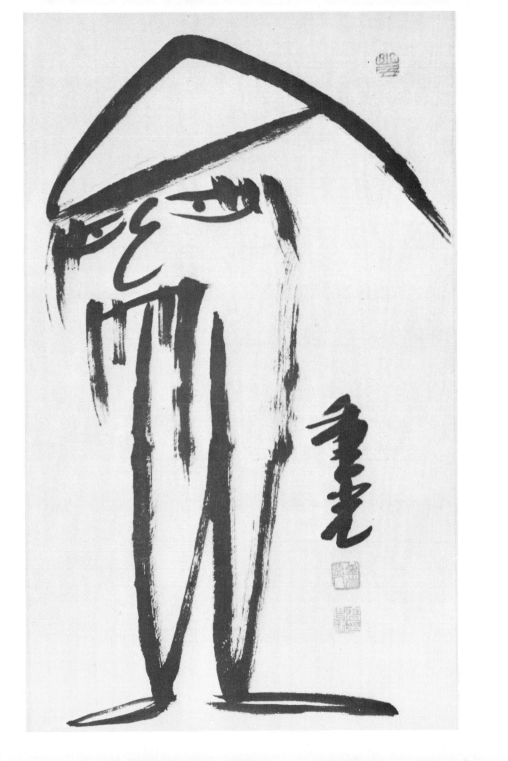

Life and Death

The white cloud, waving its hand,
Is drifting towards the western sky.

The stone Buddha in the temple hall
Keeps snoring through his nose,
Not knowing how to fly,
Awakened from deep sleep and dream.

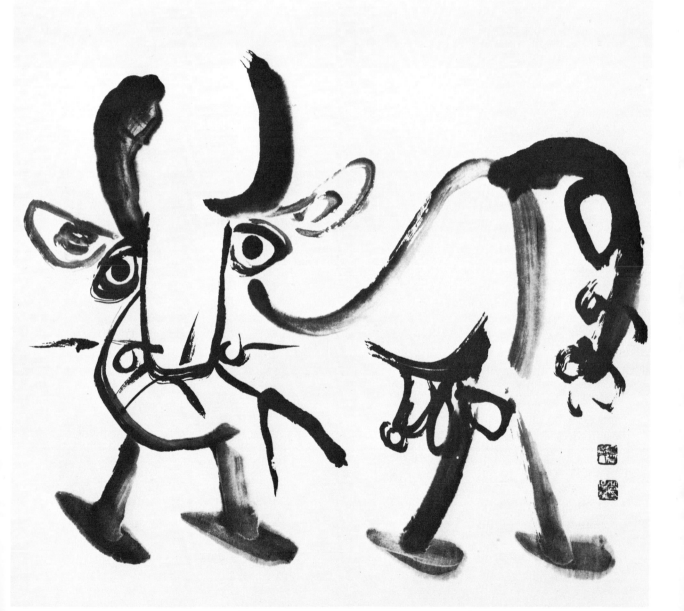

We meet a strange woman on the road.
Her hair is unkempt and her dress is not in
order. She is missing her front teeth.
Jung-kwang shouts after her, "Are you a
Mudang? (a shaman?)"
"Yes," she replies.
"Good."
She laughs.
"Mudang understand. I like to meet up
with them."

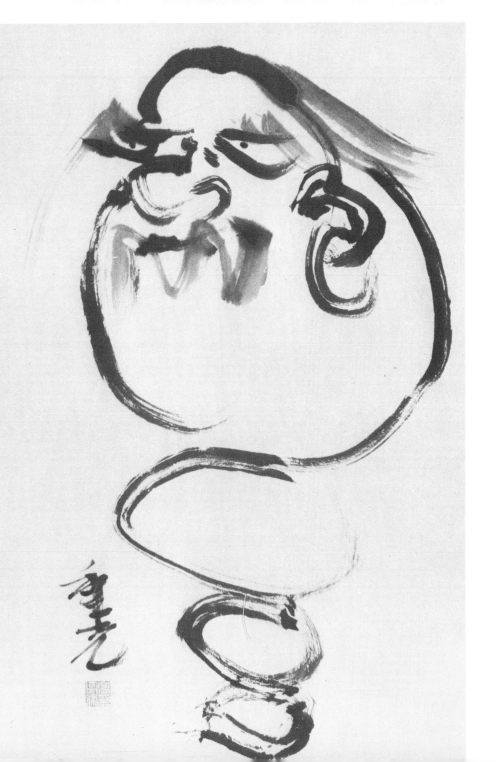

Jung-kwang starts to paint his tongue, his
teeth, his shaven head.
"Jung-kwang, what are you doing?"
"I'm painting Bodhidharma."

An orchid growing on the head of Bodhidharma.

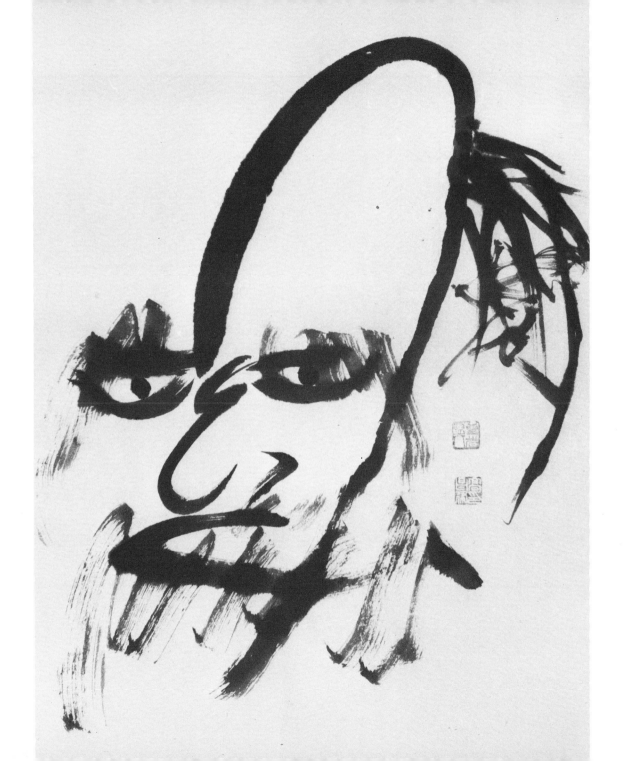

"You can see enlightenment in a painting.
Each one of mine is absolutely unique,
I could never repeat it. Never in a
thousand years."

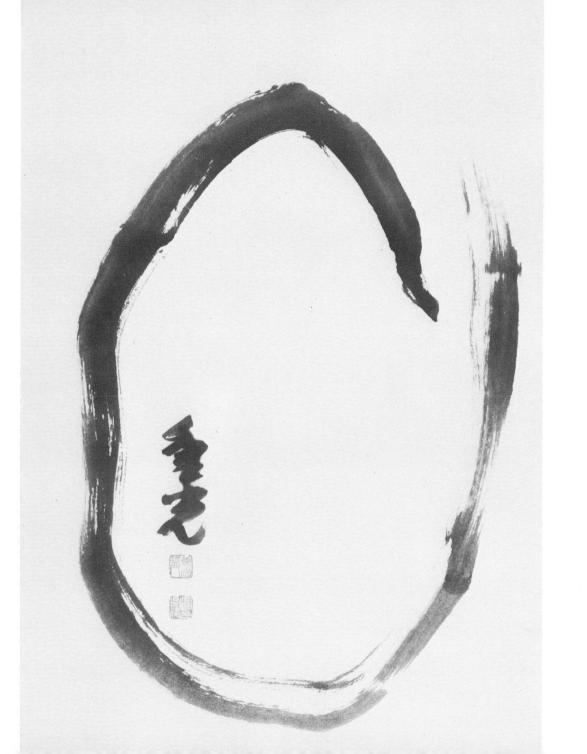

"Jung-kwang, why have you painted the
animal as if it were on the side of a vase?"
"Don't worry, any minute now it will
jump off."

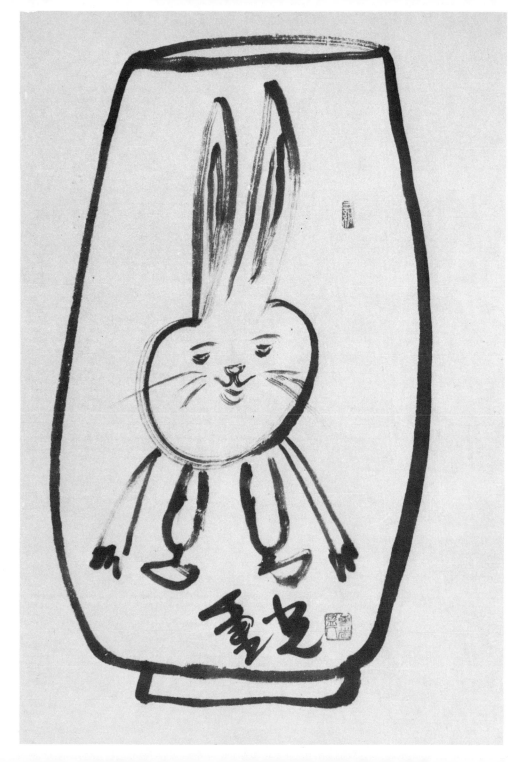

"Jung-kwang, why did you tell the press
that you have had sex with women and
animals and that you eat meat and
drink whiskey?"
He is surprised. "A man of unlimited
action must never lie. That would
be limiting."

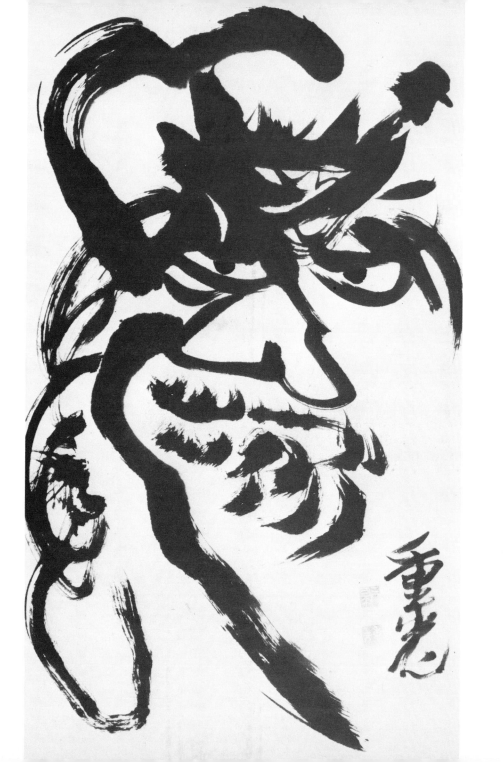

"The cock is one of my favorites. When it crows the little demons of the night run away. My cocks are special. Look! Four feet!"

Vase with a cock clapping its hands.

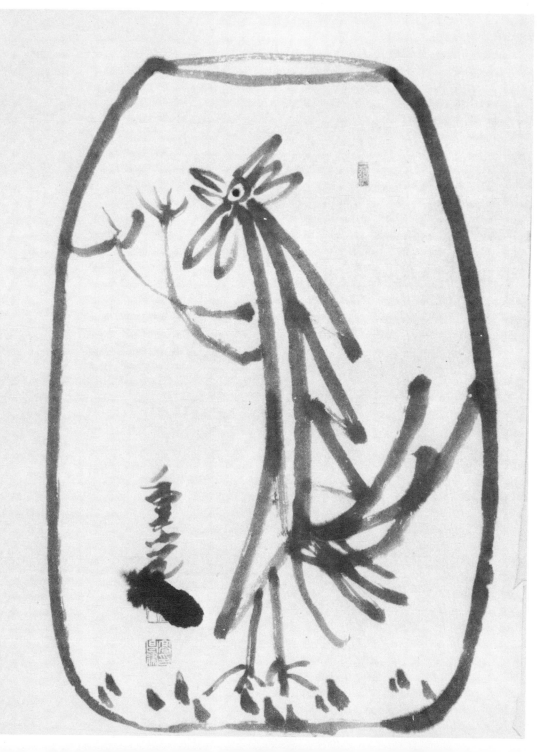

"One day there ceased to be any
difference between being in meditation
and the acts of walking, eating, sitting

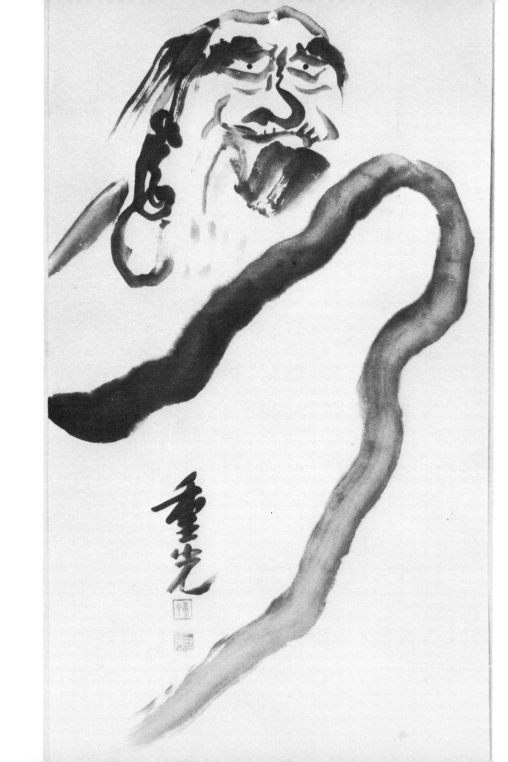

"I'm a Buddhist Mop. A mop cleans everything but gets dirty itself."

Bodhidharma crossing the river on a reed.

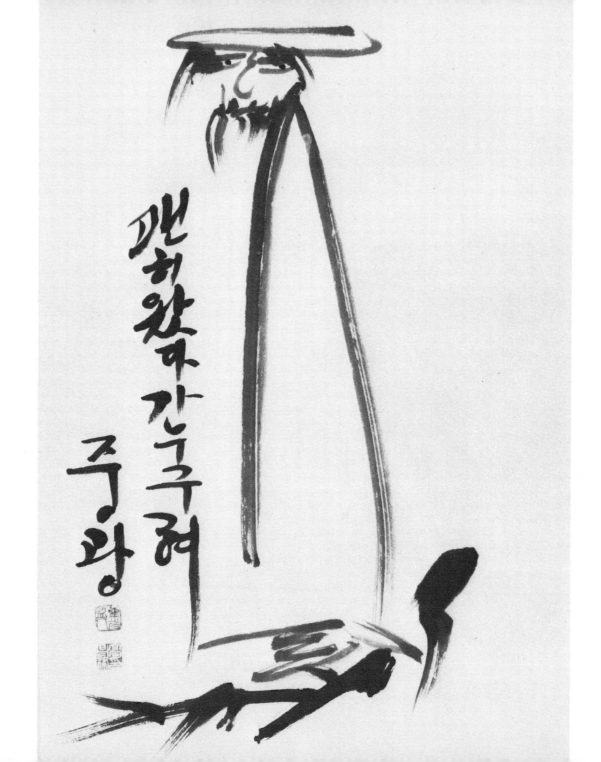

Take off those horrible clothes,
Clothes worn since the dawn of mankind.

Clothes made of the frozen ice of ideas,
Clothes made of the cunning illusion of words,
Clothes made of the hypocrisy of good and evil,
Clothes made of the sickness of society,
Clothes made of the occult arts of religions.

Humans are sick of defilements
Take off all the clothes of a slave,
Put them in the fire.

Mount a horse, naked spur and gallop.
Become one with the beasts, or be destroyed.
To the field, the road and mountains
Anywhere will do, whether there be an end or not.

Should the field be too narrow, then to the mountains,
Should the mountain be narrow, on to the ocean
Should the ocean prove too narrow, to the sky,
Lift yourself.
Should the sky be narrow, flee to the mind.
But
Do not lose the mind.

For the mind is your
Ultimate haven
The mind, without beginning or end
Is always empty. If one seeks to fill it,
No vessel is there to be found.

Awaken your self out of your maker
Who has been sold for thousands of years
Like a piece of merchandise.

Be alert and seek
The mind.
The stream in the Honguy-dong Valley
Plugging its ears,
Escapes into the village.

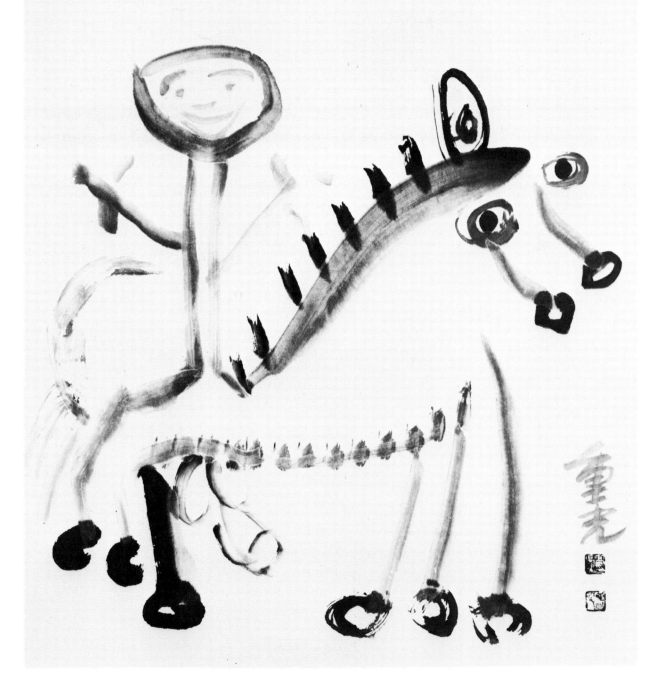

Jung-kwang points to the eye of
Bodhidarma. "There can be nothing weak
about the eye of Dharma, it must be
powerful enough to shatter all of
our illusions."

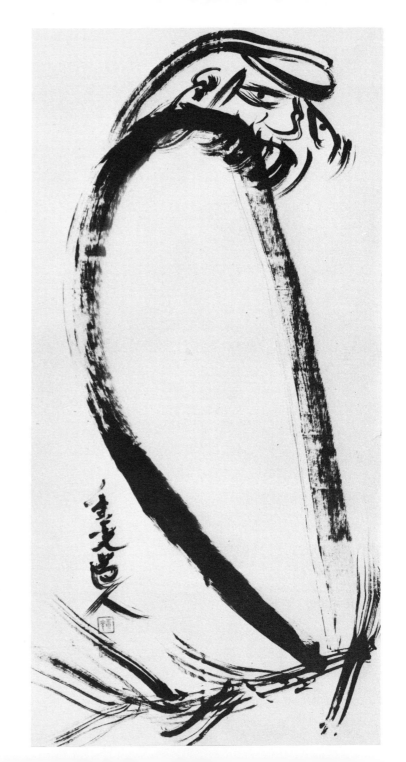

"I've had a thousand women, but not
once has the act been defiled with lust."

Bodhidharma sleeping.

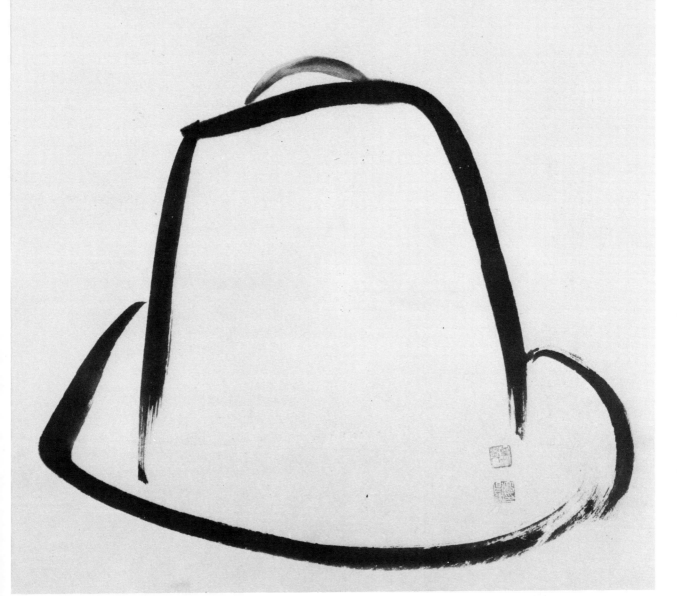

"If I pretended, unlimited action would soon wear me out. But when it is action that has no resistance there is no fatigue ever."

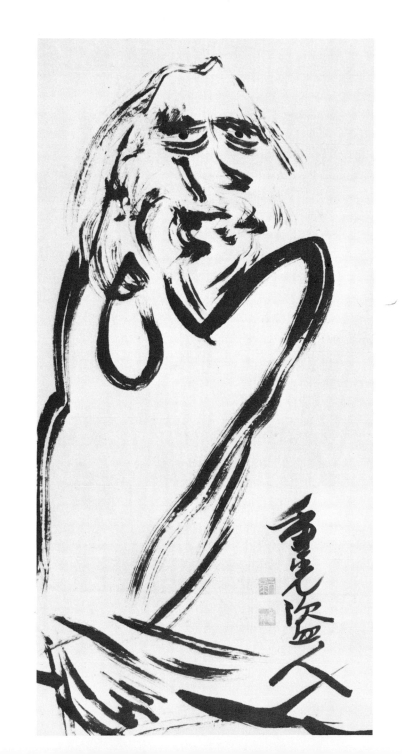

"Jung-kwang, I saw you dancing in the
moonlight last night."
"The moon was lonely last night,
so I sang to her and we danced together.
People go to sleep and forget that she
is out, waiting and watching."

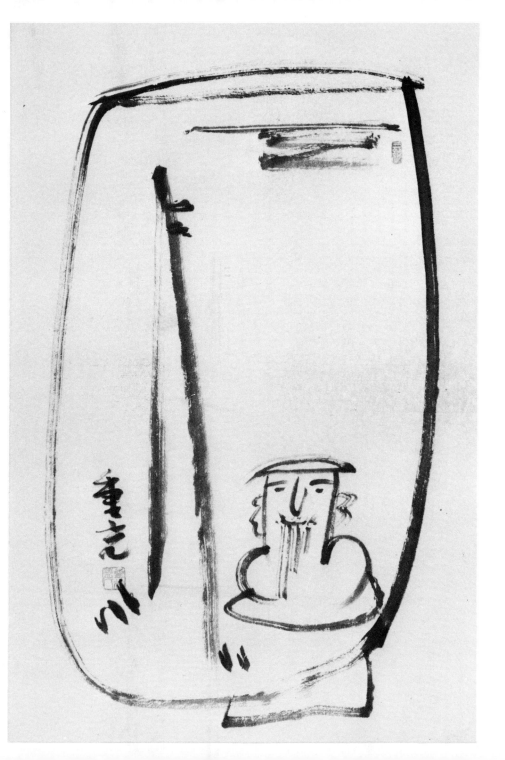

Jung-kwang lights one cigarette, then another and yet another. He puts them between his fingers and smokes all three at once. "One, two, three," he counts in English. "What need is there to be always counting?" he says in Korean.

Do not look at things with preconceived ideas.

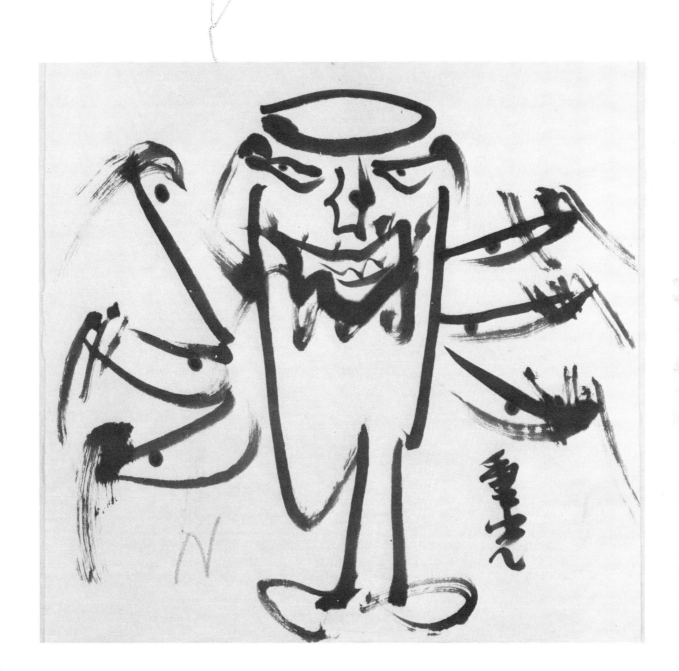

"But Jung-kwang, I'm only half finished."
"Which half? Quick show me."

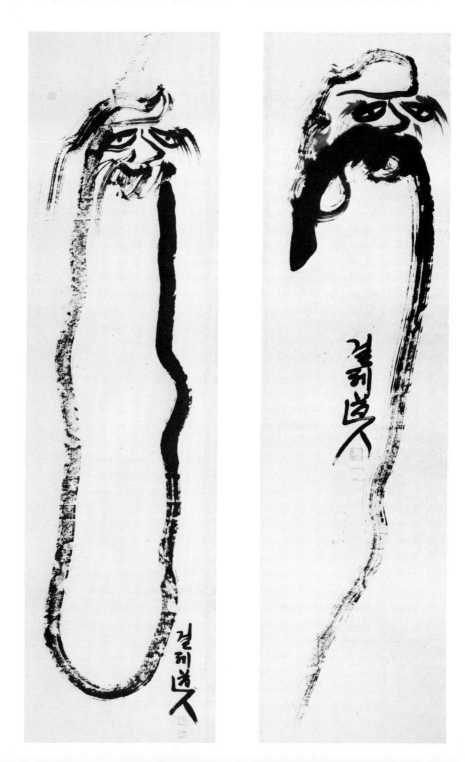

To the keeper of a little shop: "Meet the
professor! He knows all about Buddhism."
There are appropriate "ahs" and "ohs".
"The professor reads sutras," Jung-kwang
goes on, picking up an apple, "and I eat
when I'm hungry."

Bodhidharma with his straw sandals on his shoulder.

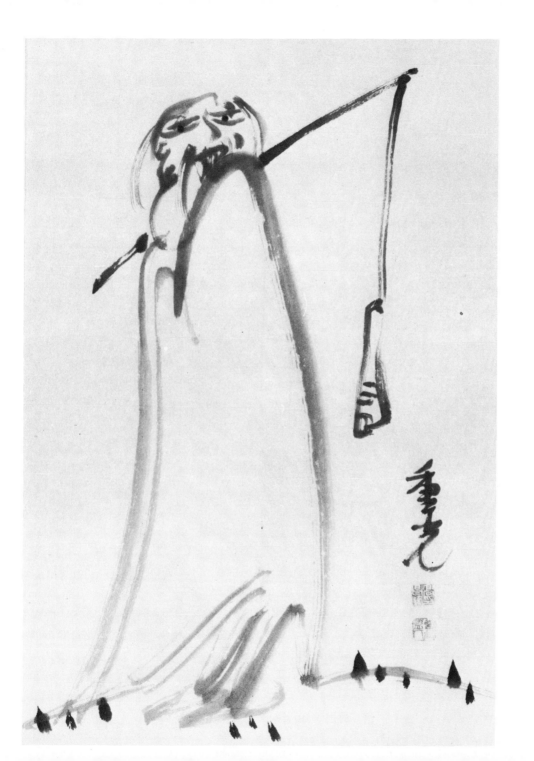

Look at the world
With your eyes taken
Away.

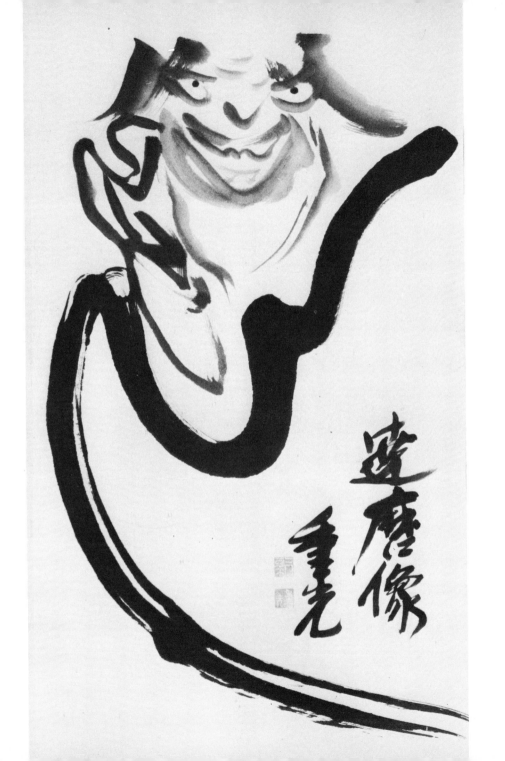

"Jung-kwang, we must say goodbye."
"Don't ever say goodbye, just sneak away
with all the spirits before the rooster
crows. I like those spirits of the night. If
they stay with me, they'll be enlightened."

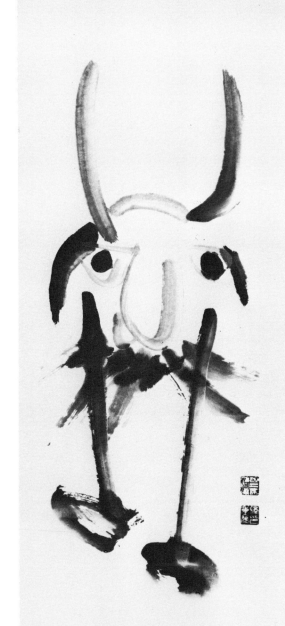

Looking at another monk's painting,
Jung-kwang says, "Smells like a
Japanese painting. Weak deliberate lines.
A man of unlimited action has lines that
are so powerful they explode."

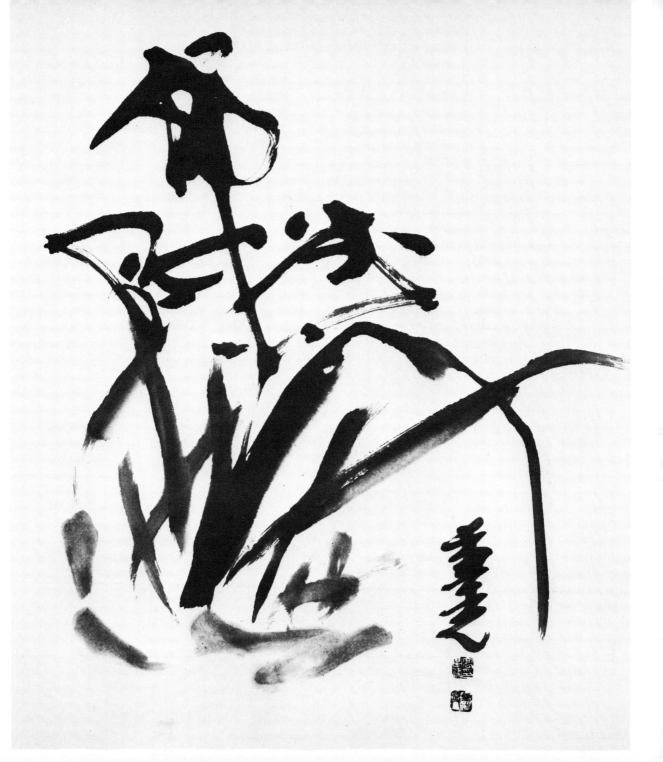

"This one must come at the end. It is my best painting."